QUOTES
—FROM—
GOATS

HOME IS WHERE
THE HERD IS

DAN MONTEIRO

CASTLE POINT BOOKS
NEW YORK

QUOTES FROM GOATS

www.castlepointbooks.com
www.stmartins.com

The Castle Point Books trademark is owned by Castle Point Publications, LLC.
Castle Point books are published and distributed by St. Martin's Press.

ISBN 978-1-250-19979-9 (paper over board)

Design by Katie Jennings Campbell

Cover and interior images used by permission from Shutterstock.com

Our books may be purchased in bulk for promotional, educational,
or business use. Please contact your local bookseller or the
Macmillan Corporate and Premium Sales Department at 1-800-221-7945,
extension 5442, or by e-mail at MacmillanSpecialMarkets@macmillan.com.

First Edition: November 2018

10 9 8 7 6 5 4 3 2 1

FROM A GOAT'S INSTINCTIVE DESIRE

to scale every mountain to its shocking and limitless diet, this hairy rebel, more than any other, knows how to live life to the fullest. *Quotes from Goats* is a photographic celebration of the bold and beloved goat and everything it teaches us about love and life.

Inside you'll find goats of all ages and sizes with personalities as diverse as the landscapes they graze. Some are natural entertainers: They pick fights, hop fences, and smile broadly for the camera. Others are born philosophers: They are soulful, trusting, and curious about their surroundings. If this ragtag band of bovids could speak, their quotes would inspire and enlighten us. *Quotes from Goats* brings the mysterious inner world of goats to life on the page and reveals the wisdom of their ways.

We could all take a lesson from the brazen, unsung guru of the barnyard: the all-knowing goat.

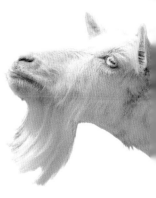

THE BEST VIEW
COMES AFTER THE
HARDEST CLIMB.

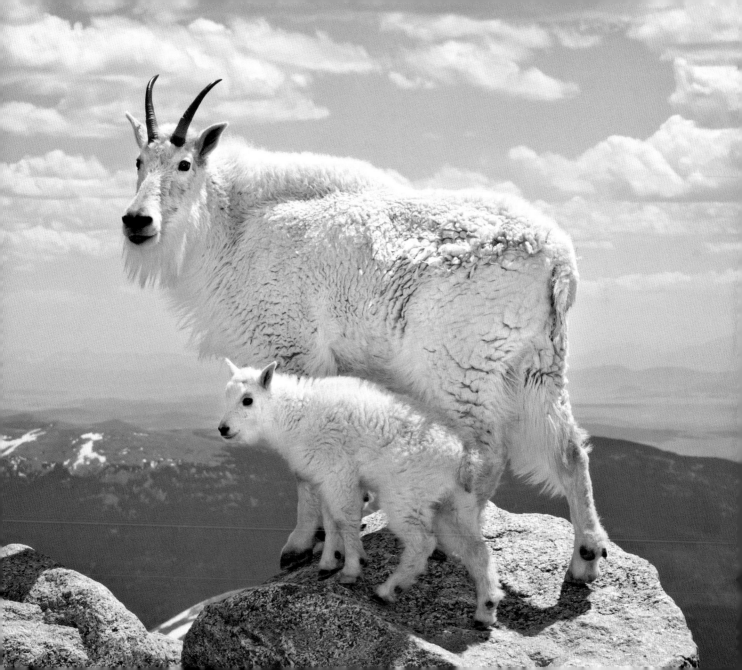

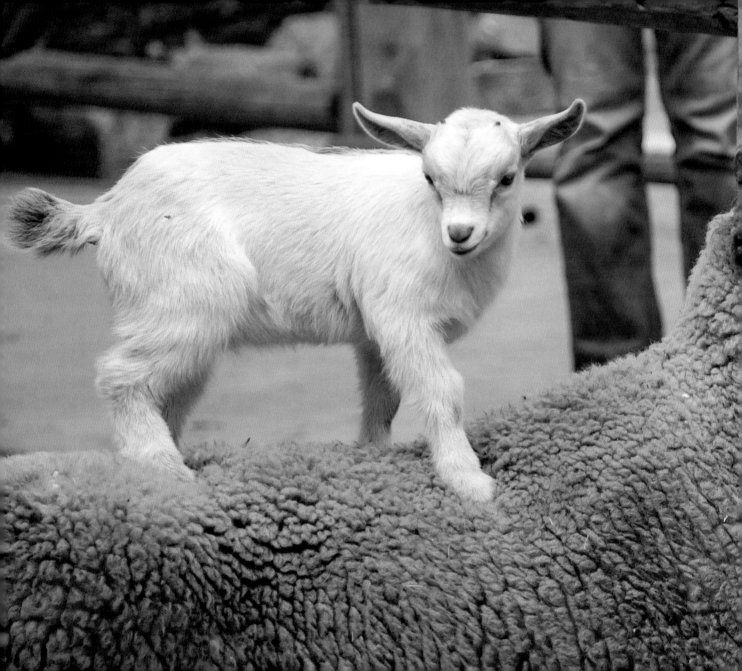

TAKE A WALK ON THE WILD SIDE.

IF YOU WANT TO LEARN A LOT,

MAKE FRIENDS WHO ARE DIFFERENT FROM YOU.

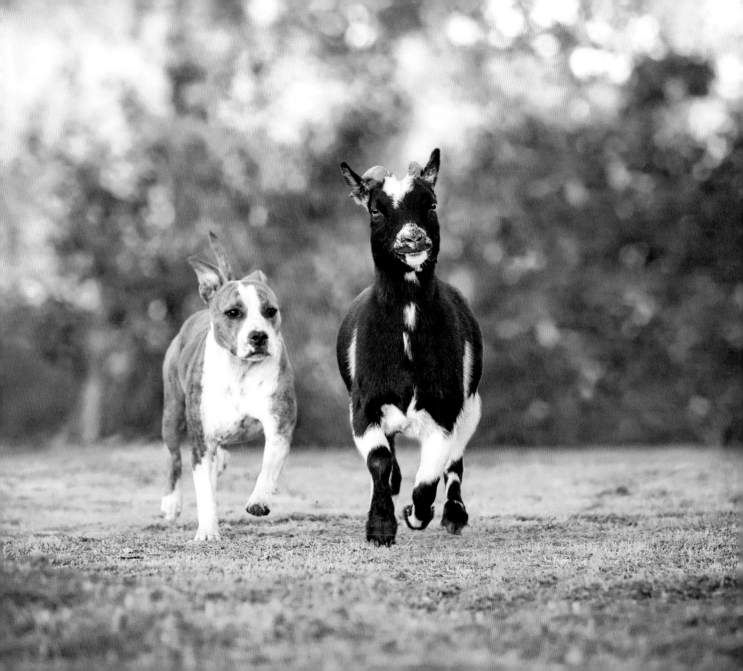

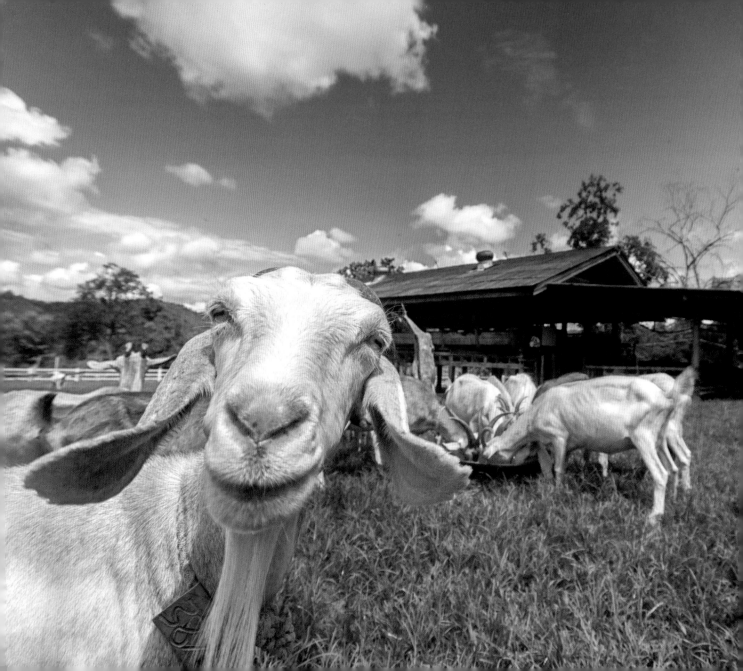

NEVER SKIP FAMILY DINNERTIME.

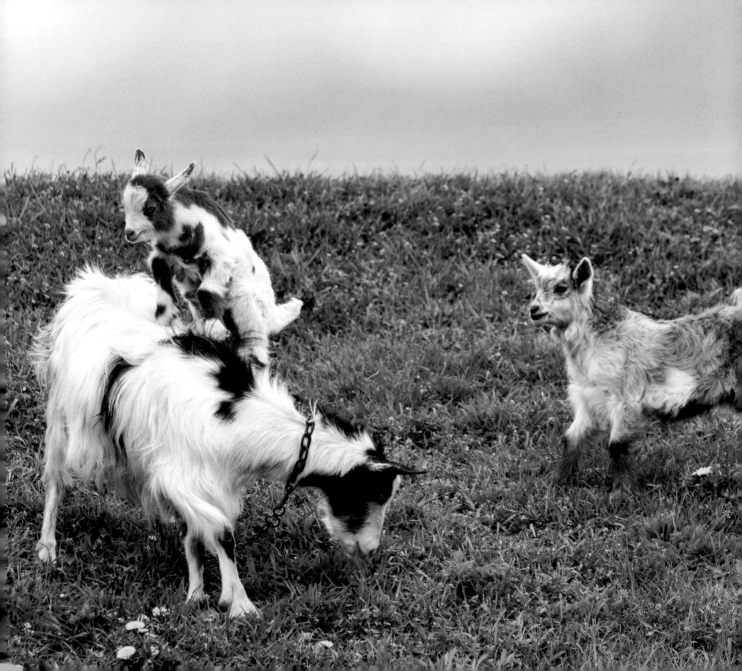

YOU NEVER KNOW UNTIL YOU TRY.

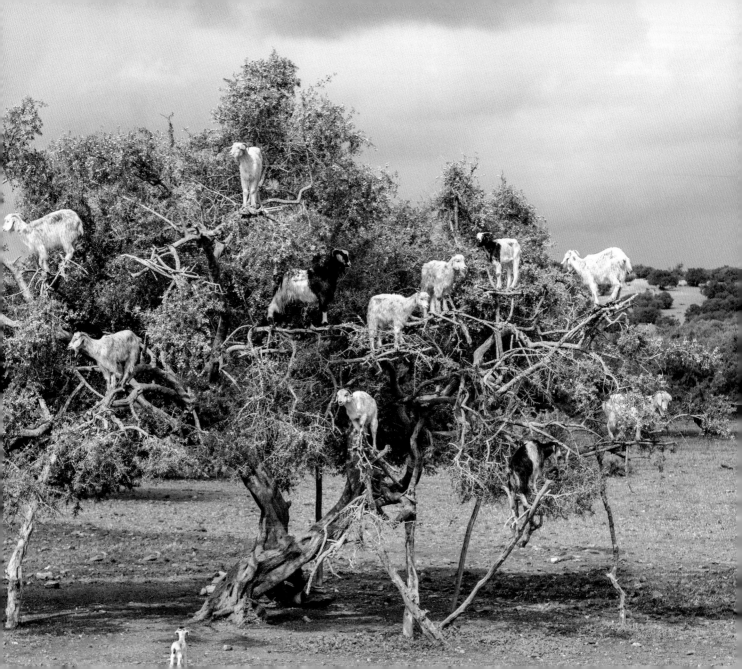

THERE'S NOTHING THAT CAN'T BE SOLVED WITH A LITTLE LOVE.

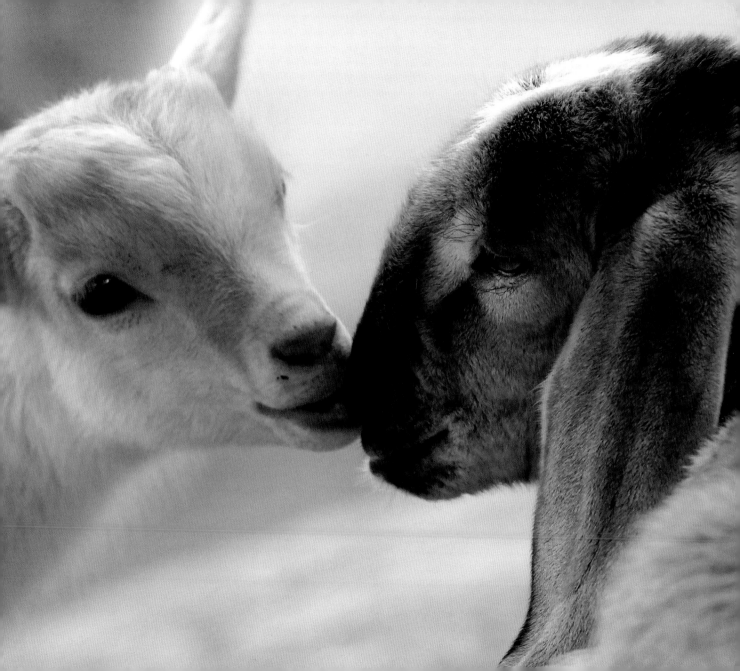

YOU DON'T HAVE

TO BE BIG
TO BE TOUGH.

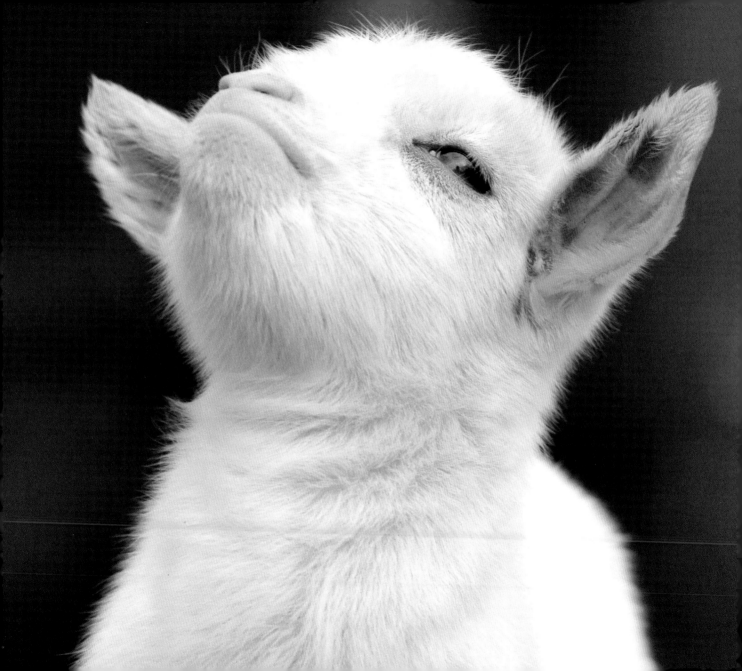

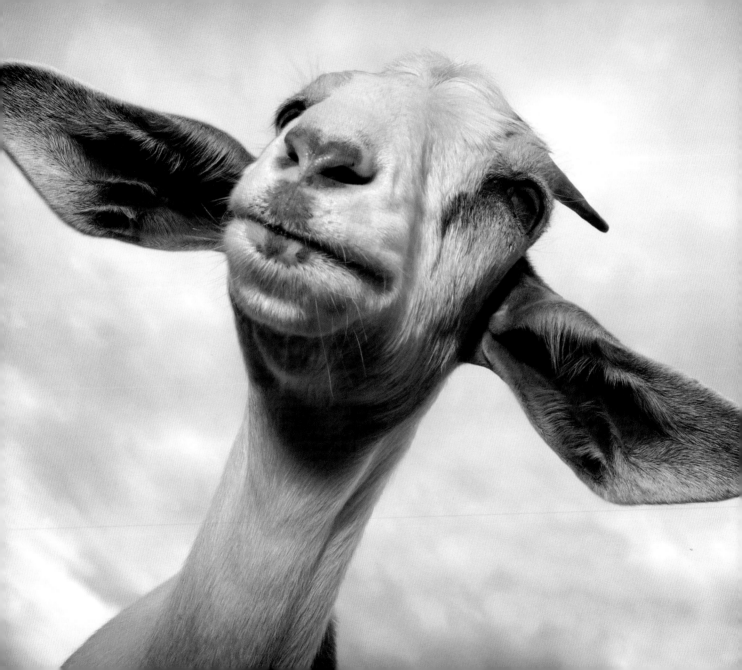

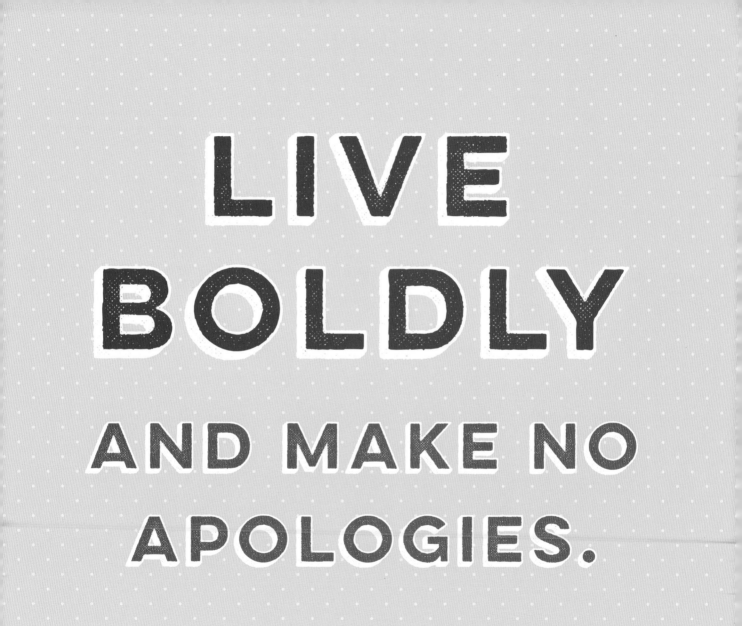

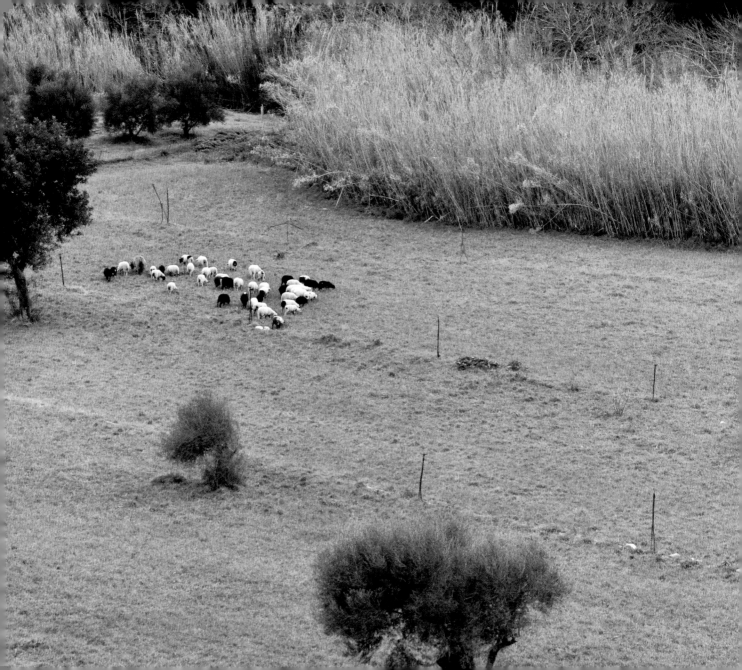

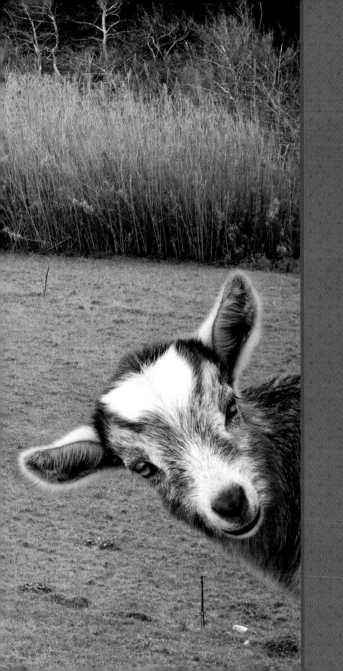

HOME IS WHERE THE HERD IS.

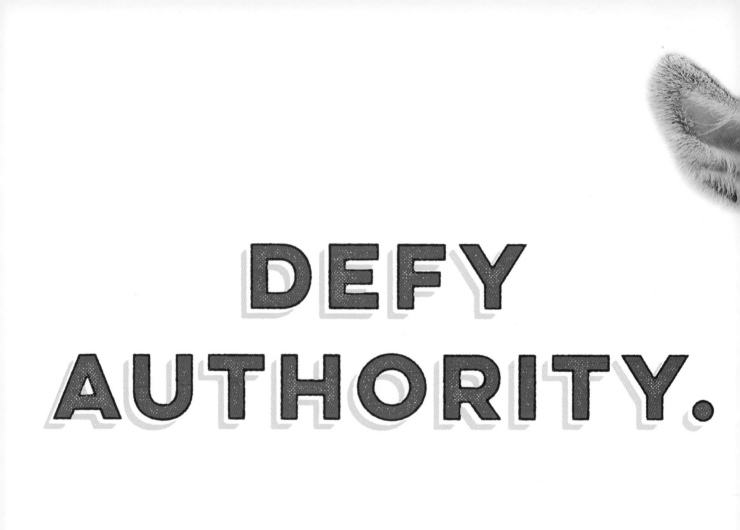

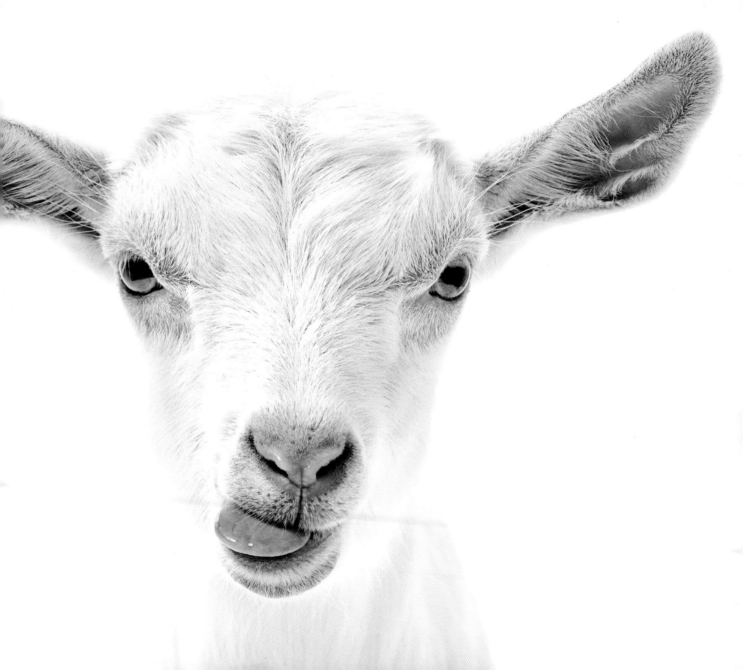

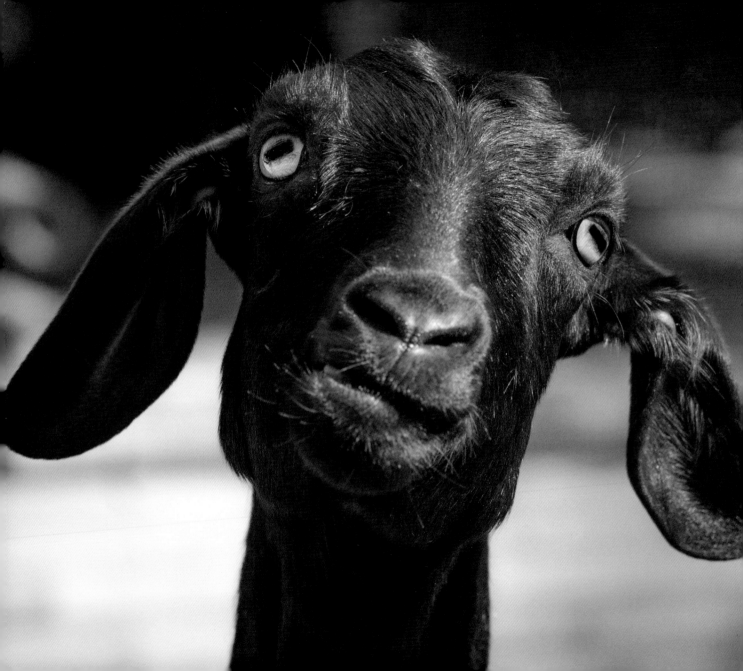

LOOK FOR
MEANING,
BUT IF YOU
COME UP EMPTY
THAT'S OKAY.

YOU MIGHT BE SCARED. YOU MIGHT DOUBT YOURSELF. BUT TAKE THE LEAP.

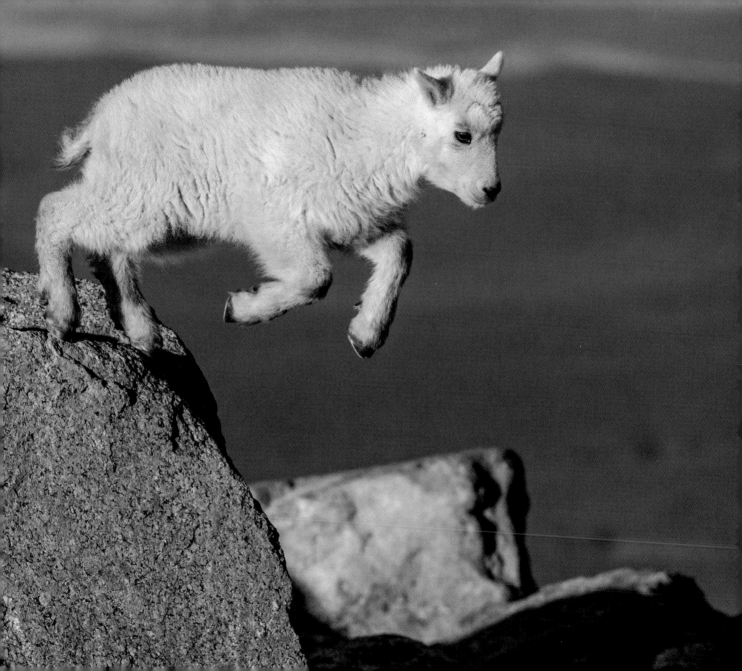

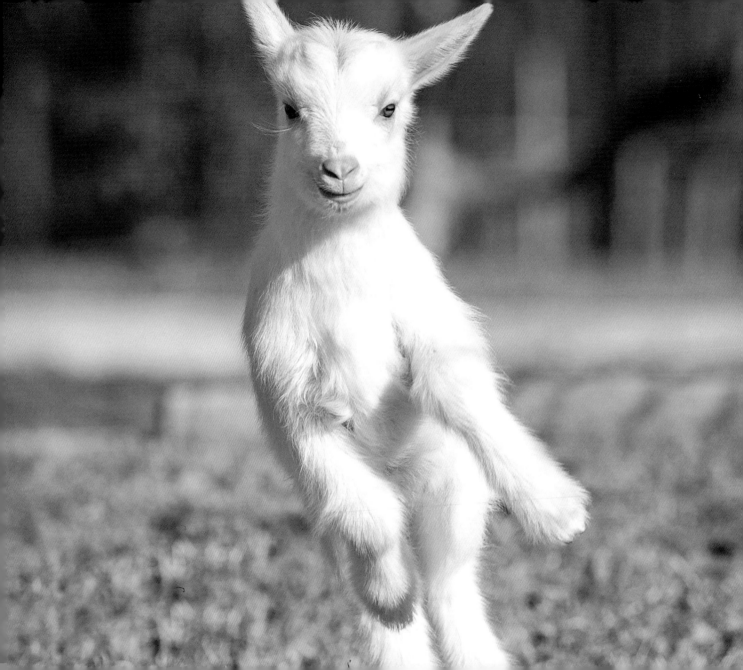

SOME THINGS ARE WORTH FIGHTING FOR.

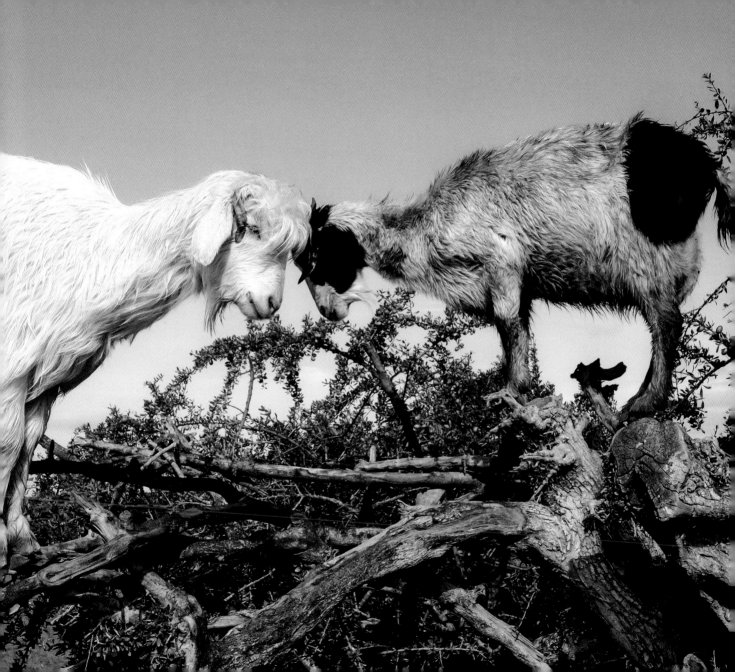

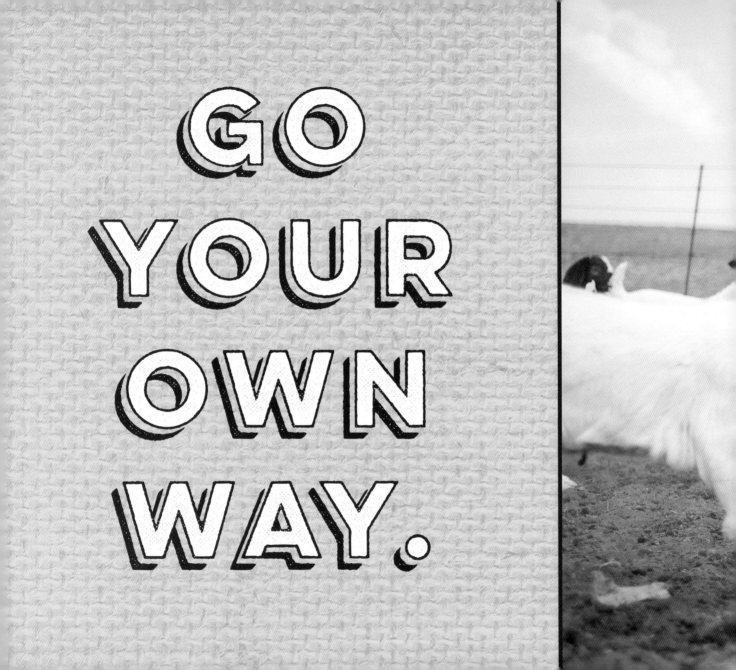

GO YOUR OWN WAY.

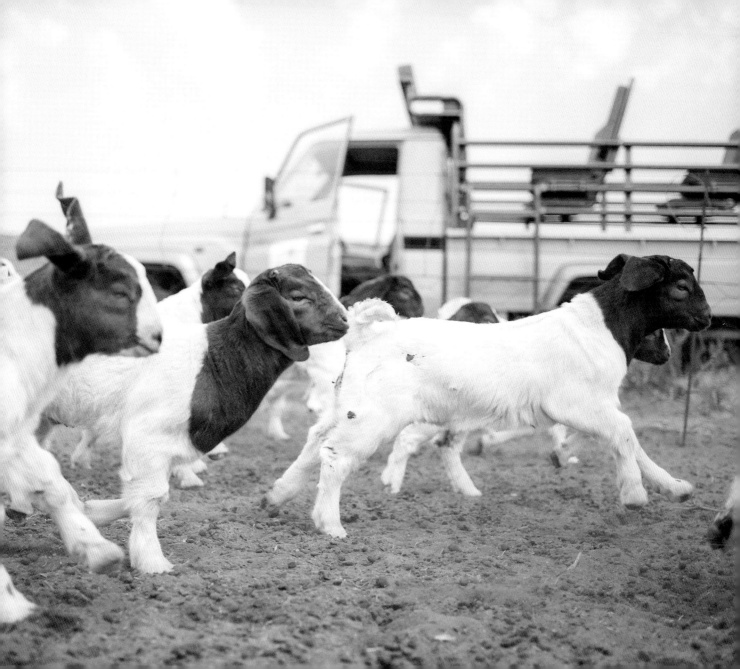

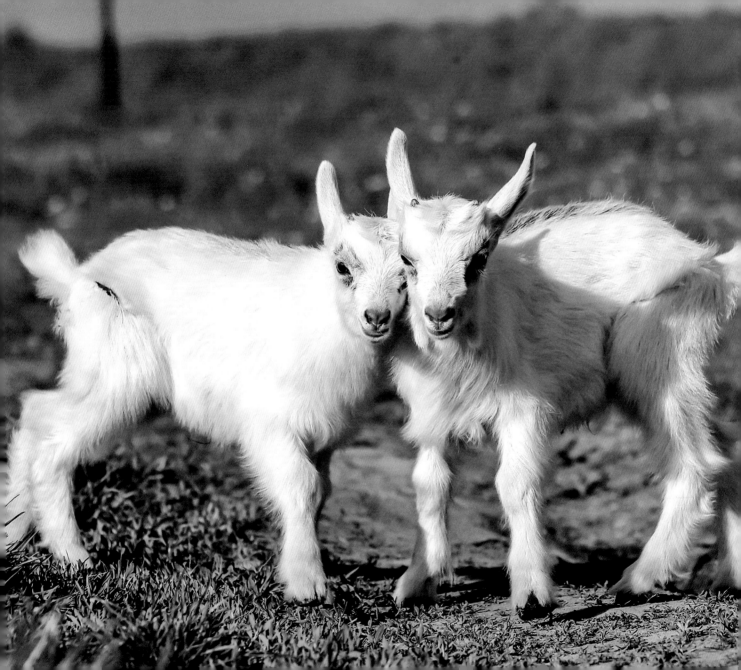

FRIENDS
ARE THE BRIGHT
BLOSSOMS
ON THE PASTURE
OF LIFE.

THE FIRST STEP IS THE HARDEST.

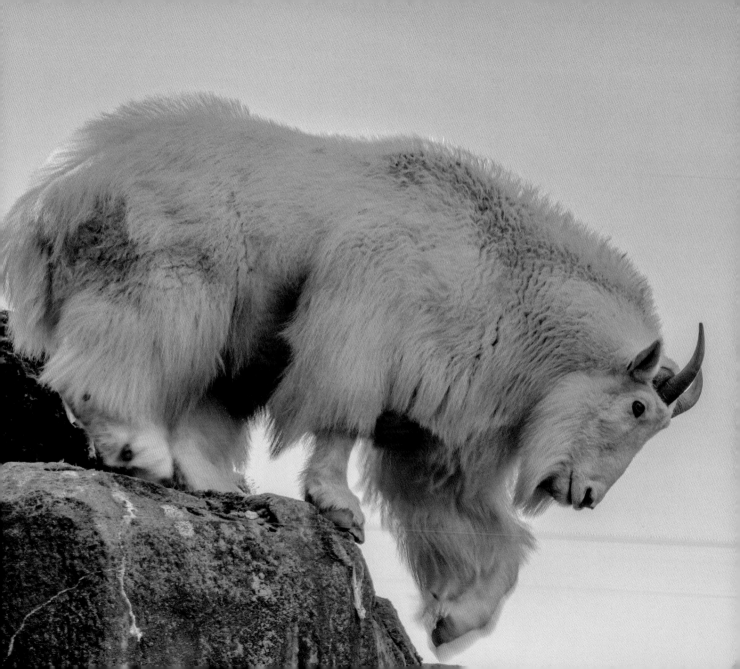

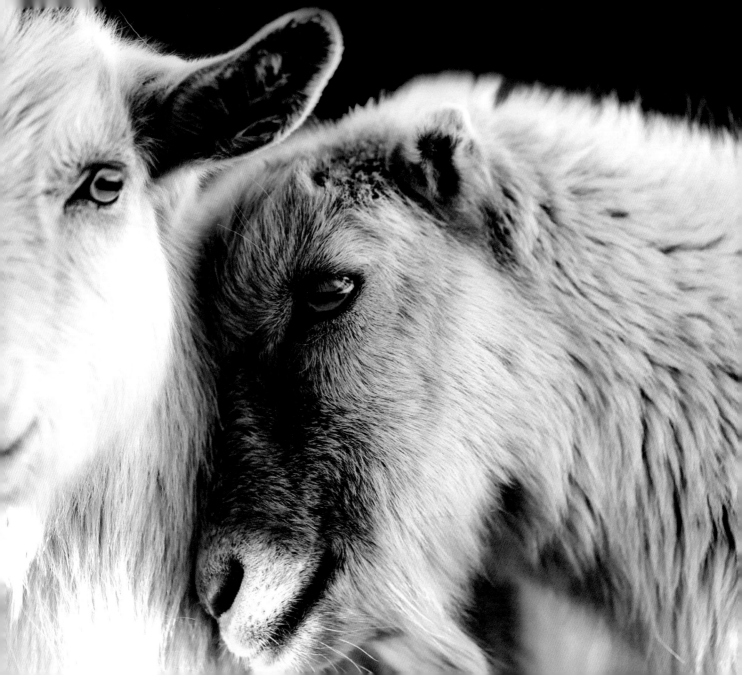

SPEND TIME
— WITH —
YOUR KIDS.

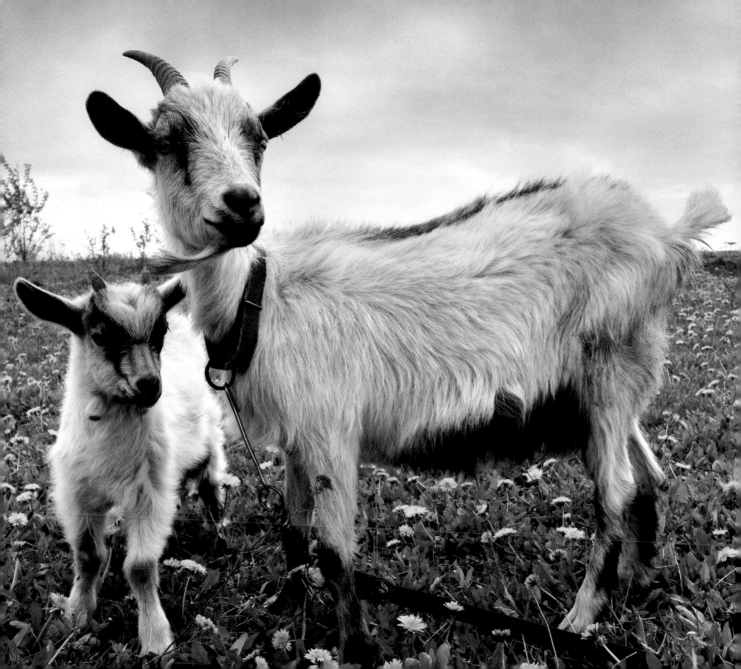

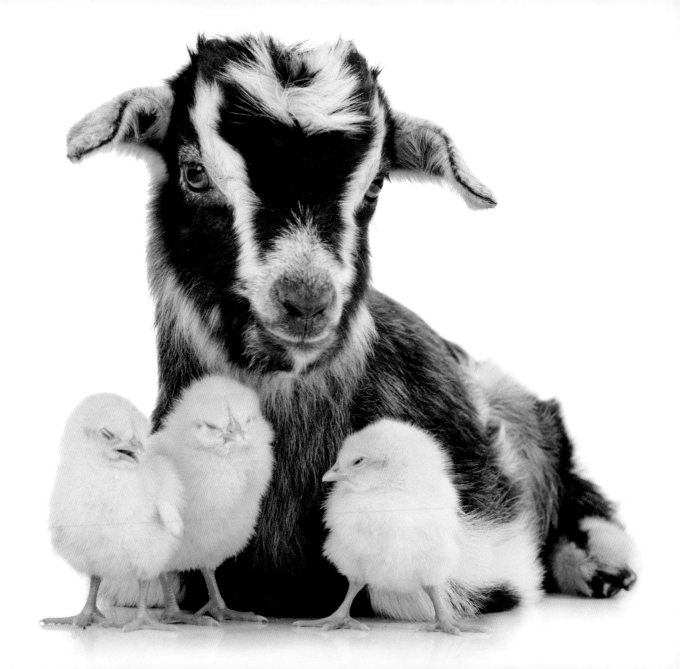

CELEBRATE
DIFFERENCES.

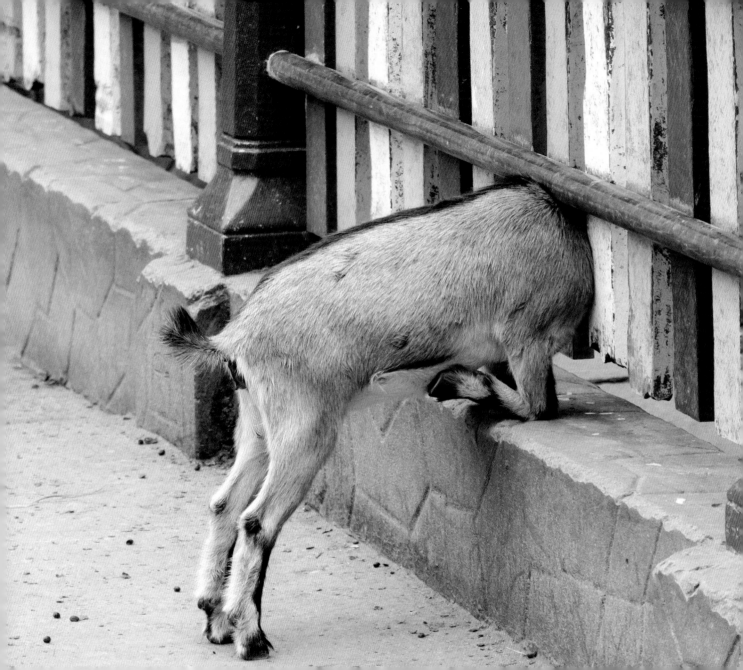

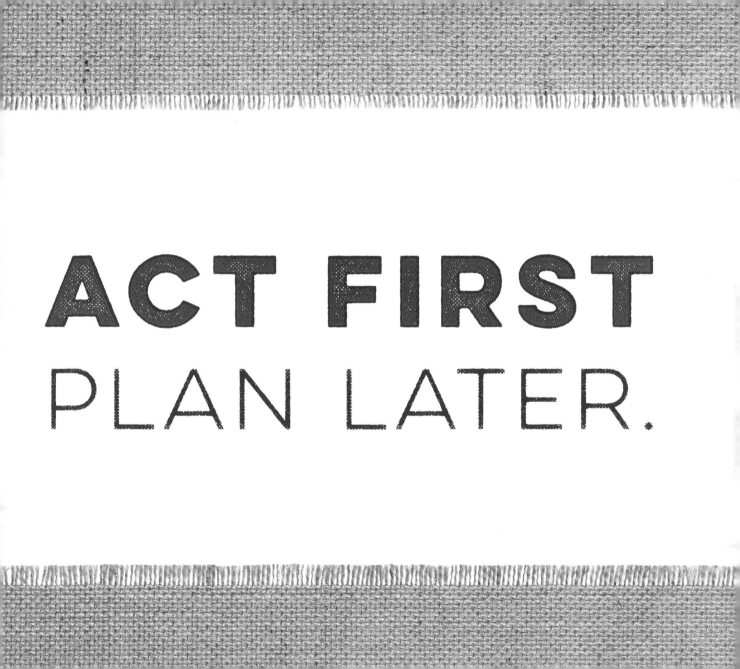

WITH
GREAT BEARD
COMES GREAT
RESPONSIBILITY.

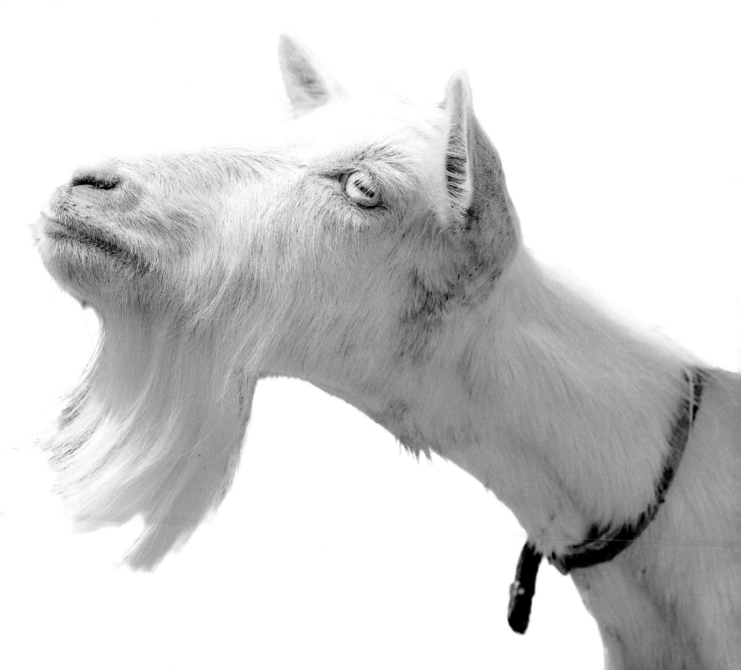

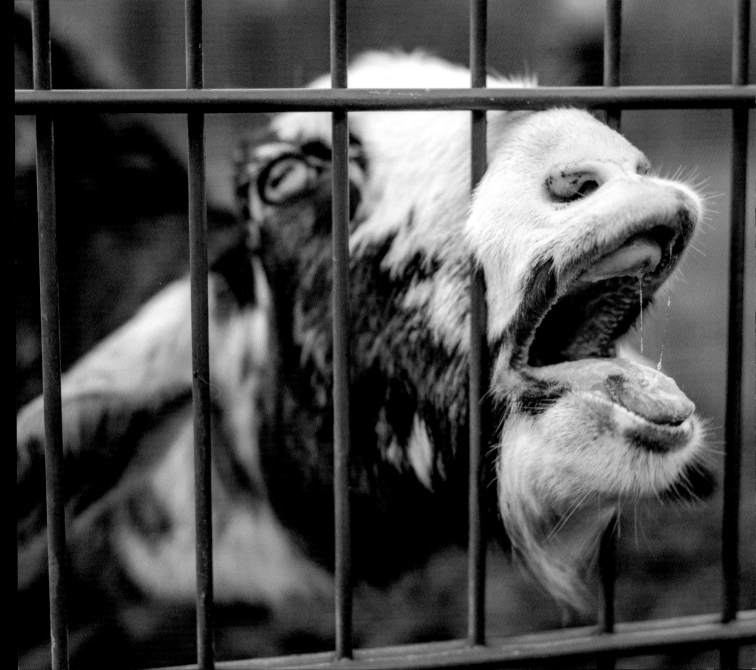

SOMETIMES ACTING CRAZY MAKES PERFECT SENSE.

LOVE
KNOWS NO
BOUNDARIES.

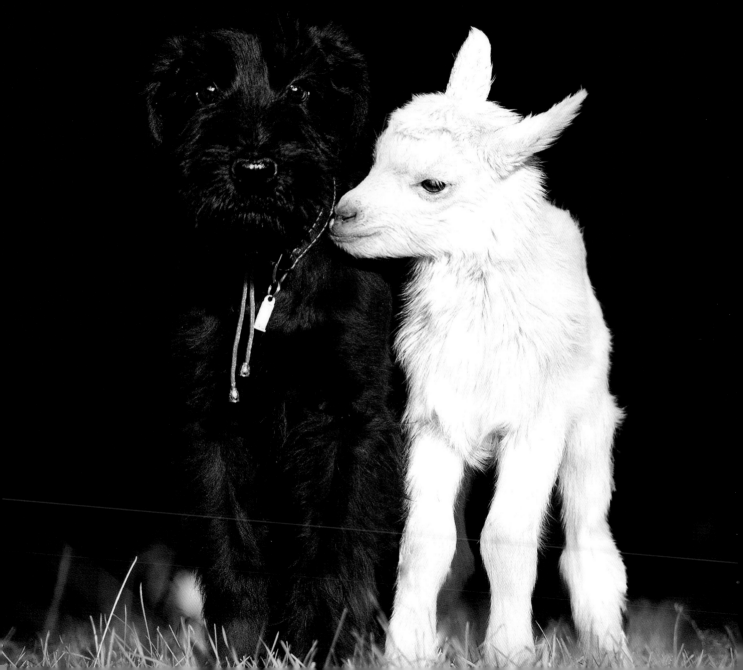

NOT EVERY GOAT WHO WANDERS IS LOST.

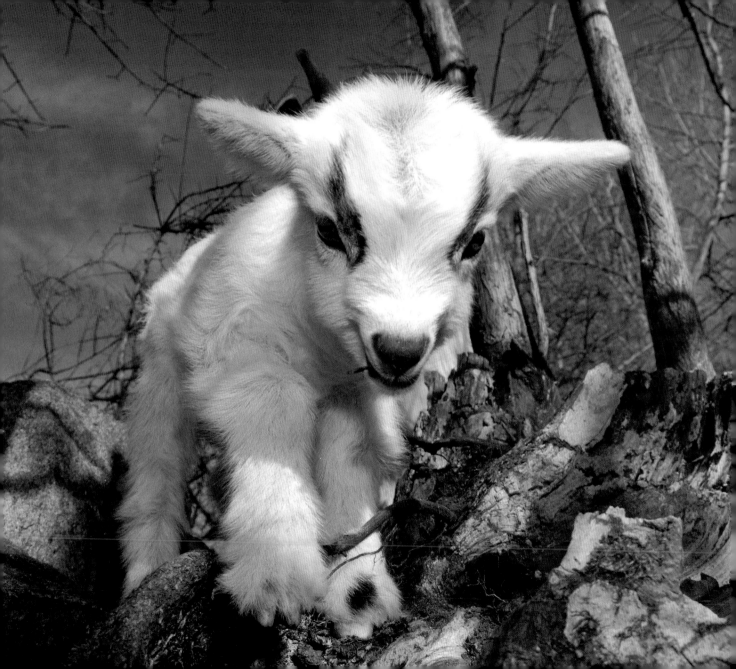

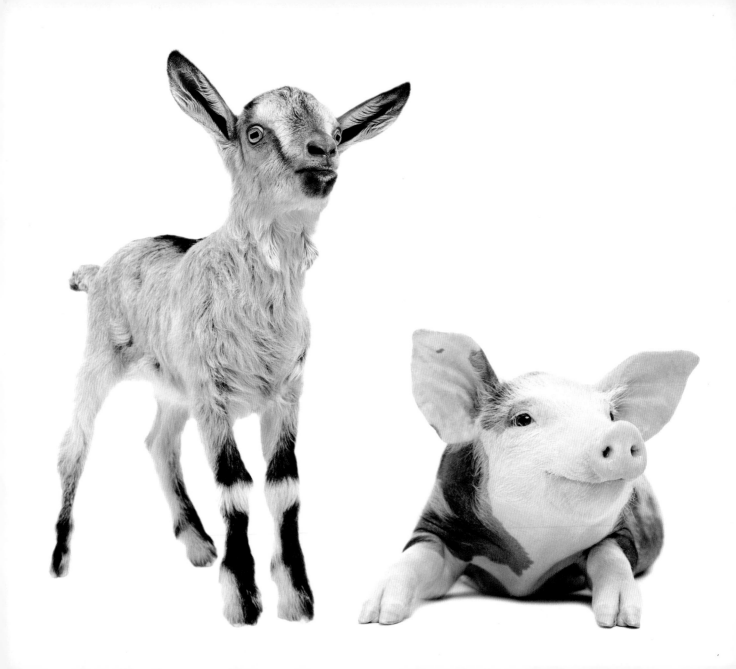

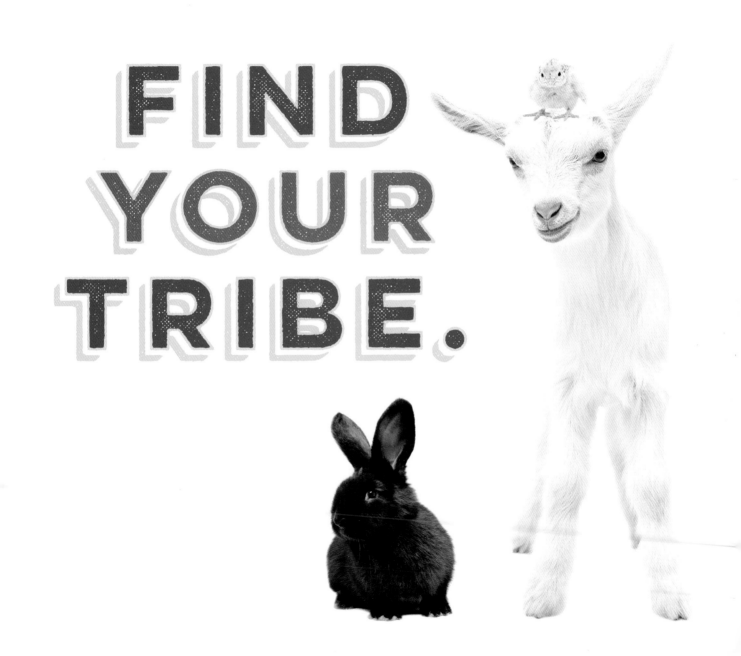

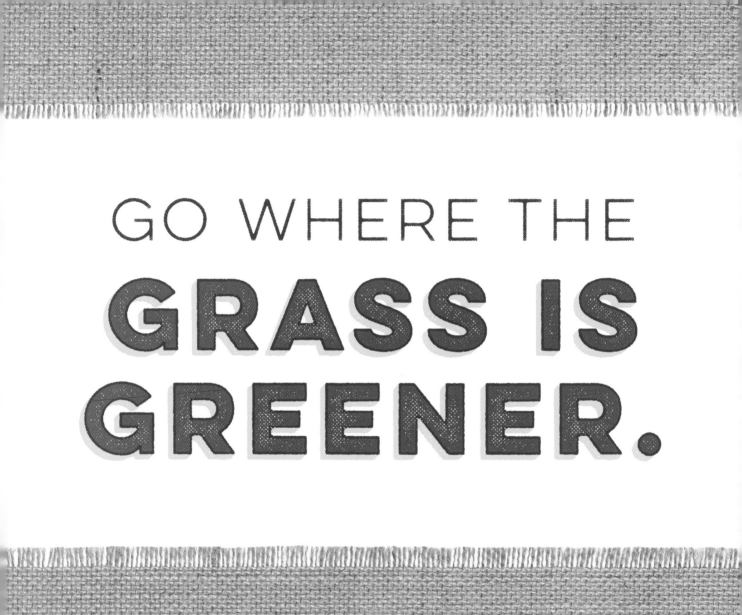

GO WHERE THE
GRASS IS
GREENER.

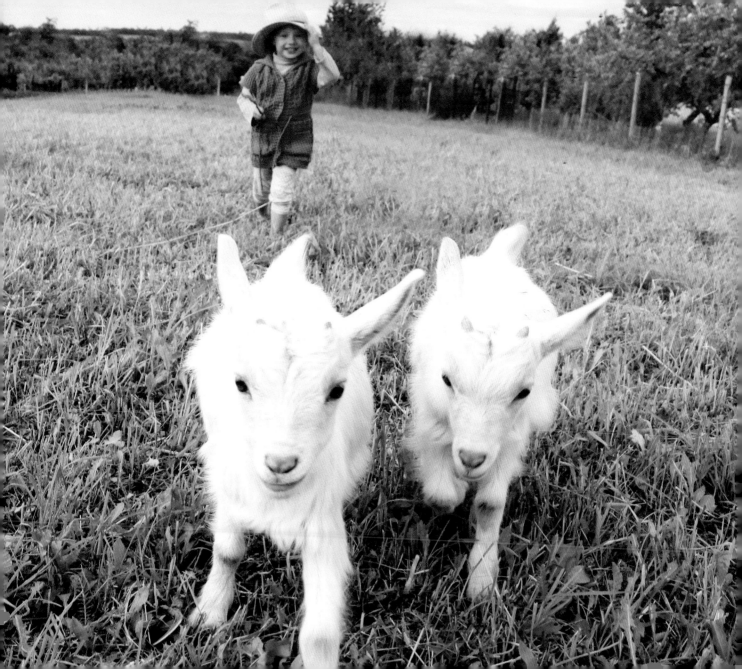

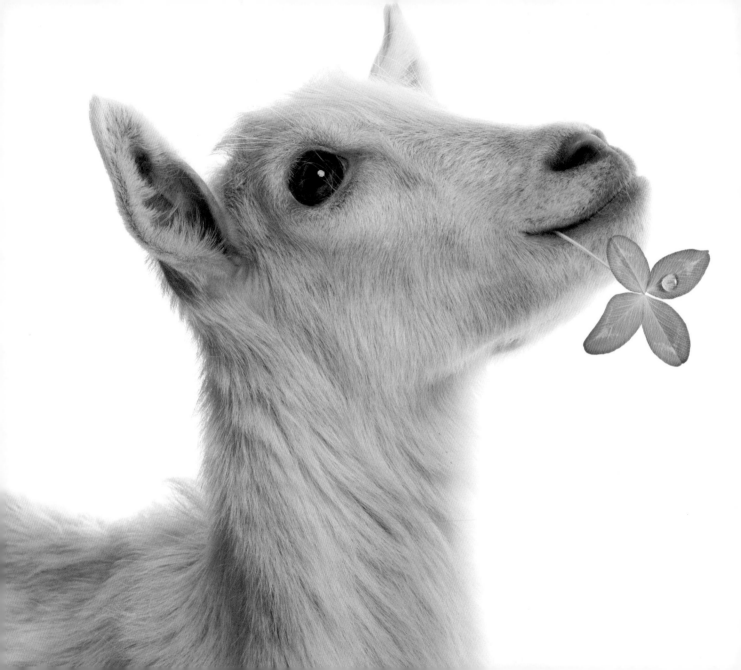

LET YOURSELF BE PAMPERED.

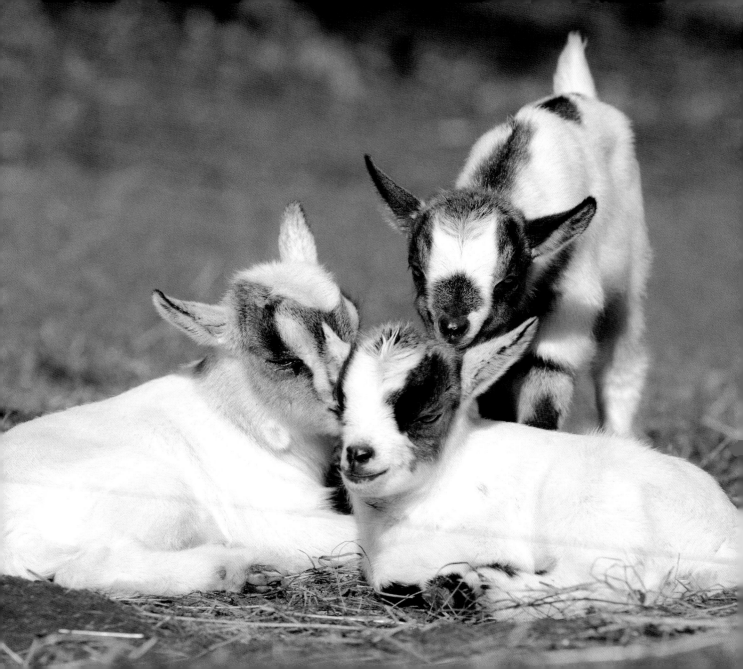

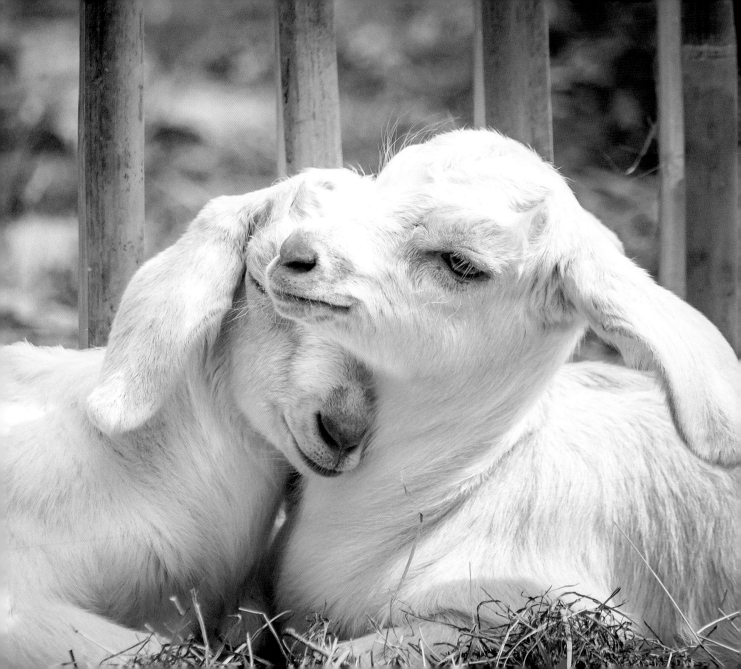

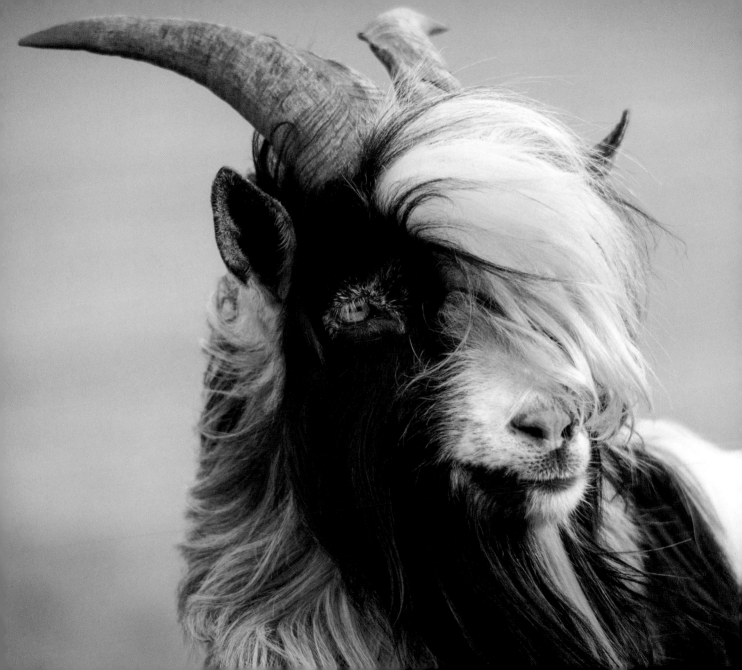

BE
AWESOME
EVERY
DAY.

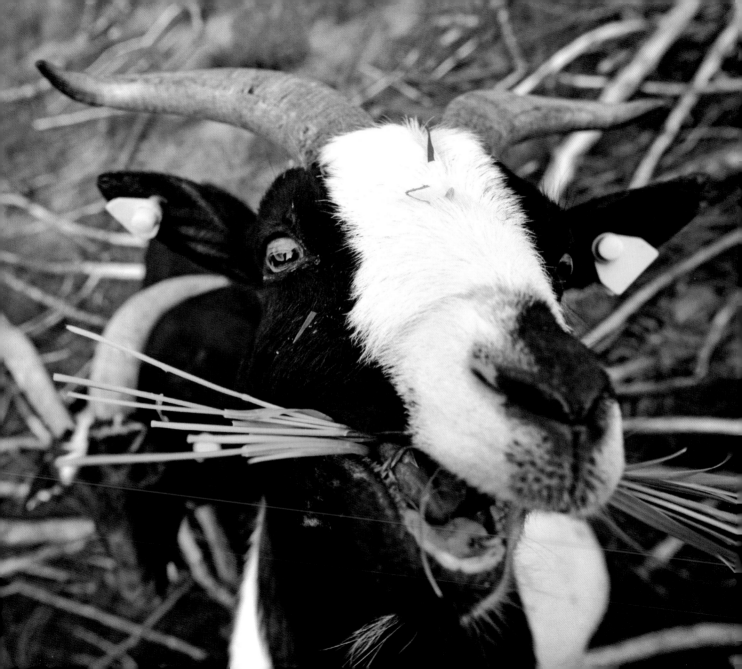

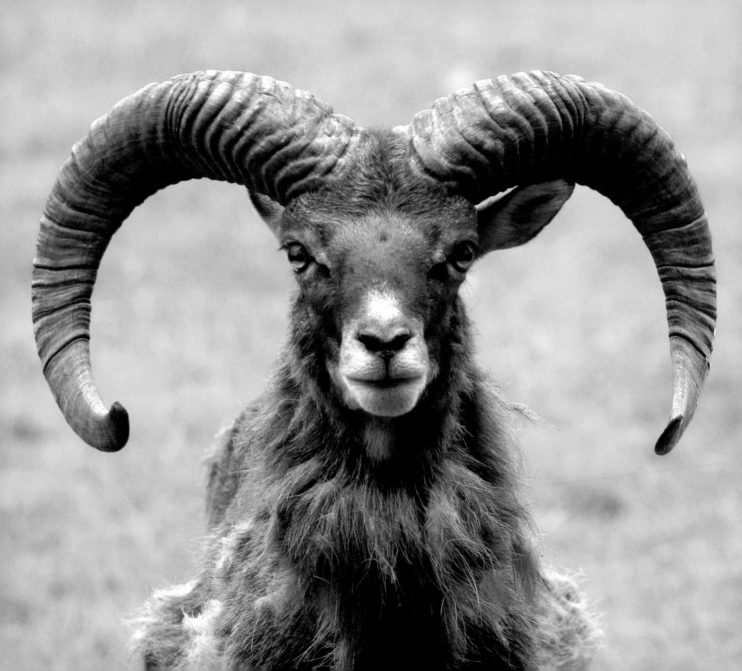

GRAB LIFE BY THE HORNS.

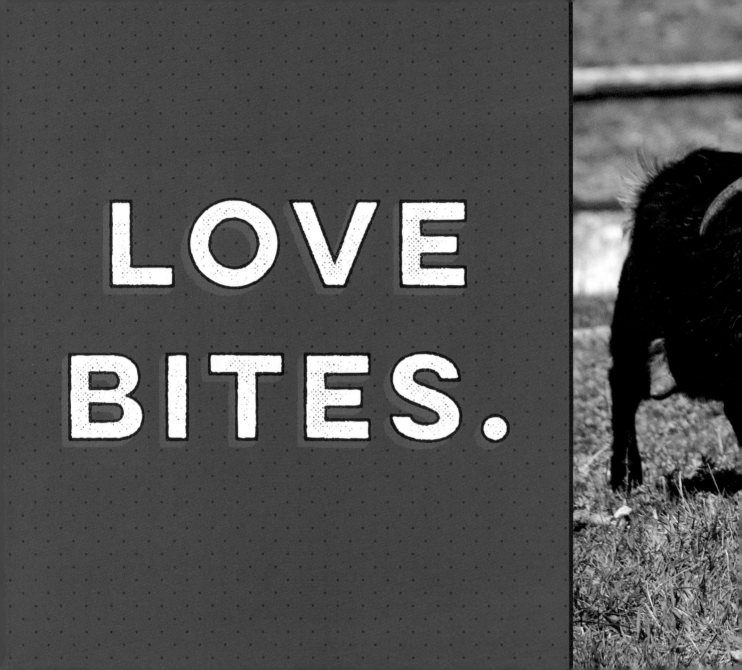

LOVE
BITES.

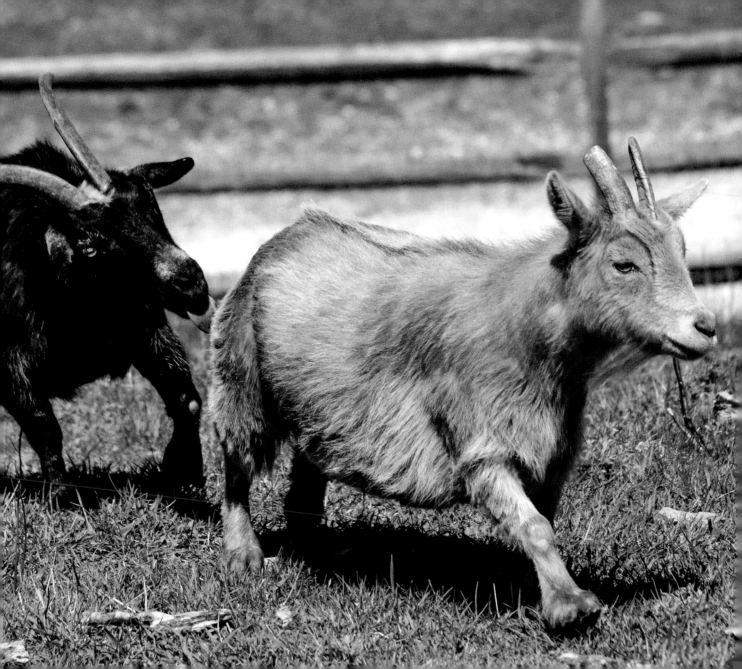

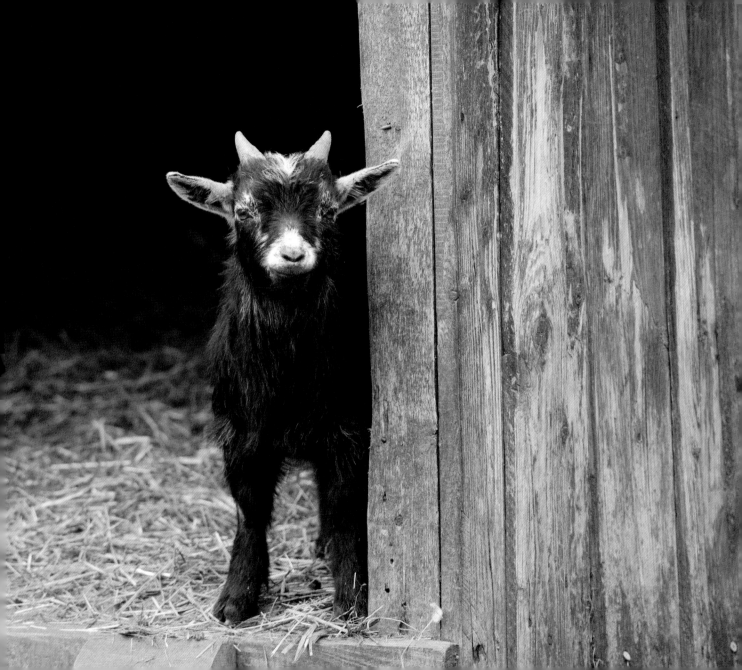

YOU CAN'T GRAZE THE PASTURE IF YOU DON'T LEAVE THE BARN.

DON'T BELIEVE EVERYTHING YOU HEAR.

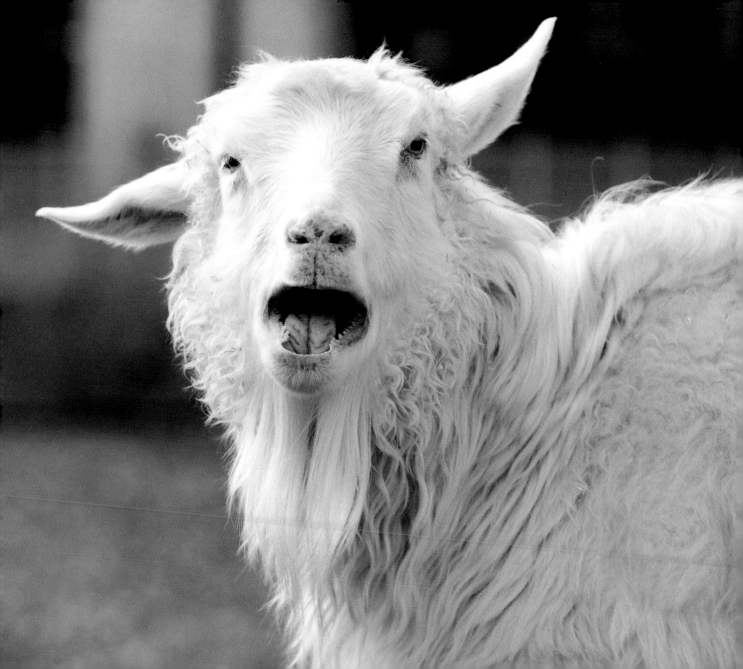

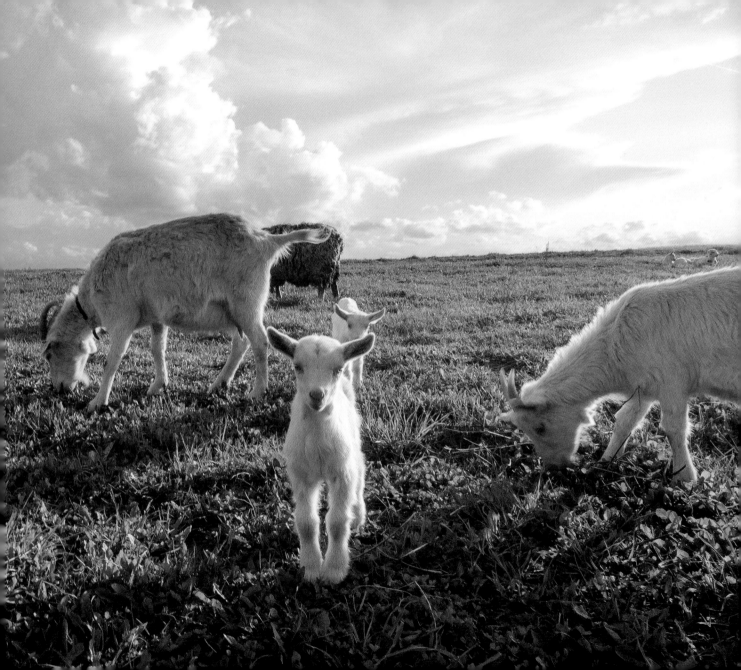

THERE'S ALWAYS HOPE ON THE HORIZON.

SURPRISE YOURSELF.

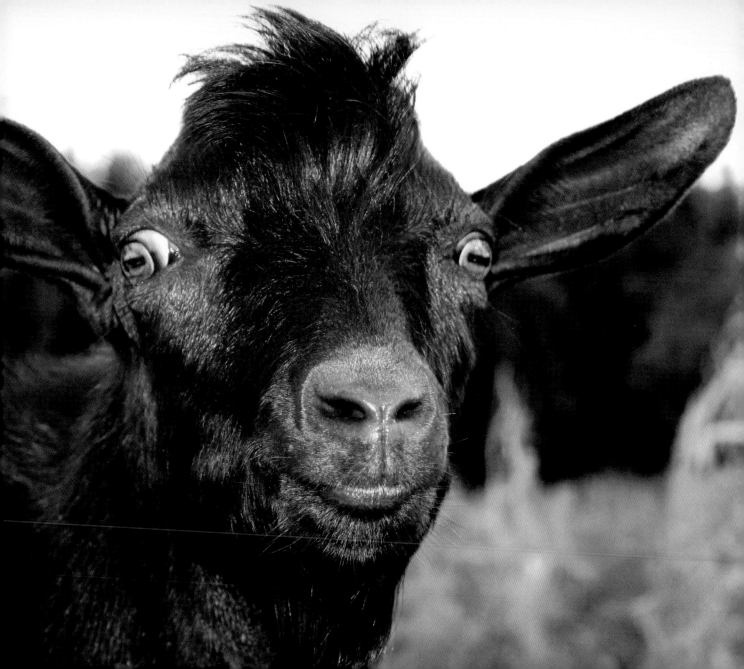

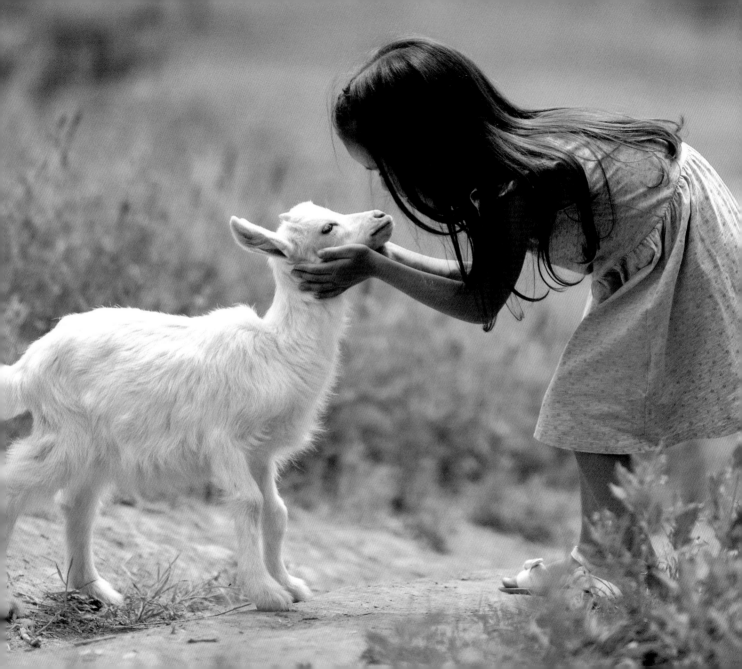

WHERE THERE'S A HILL THERE'S A WAY.

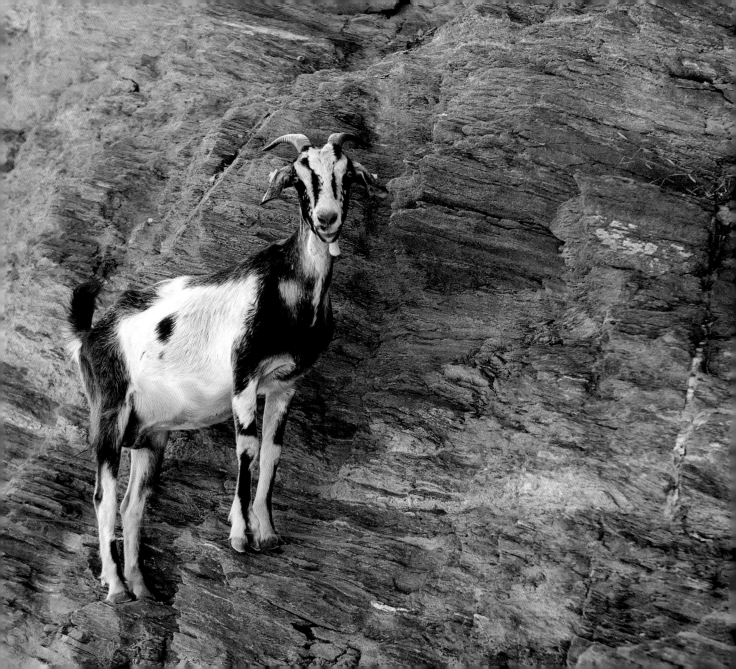

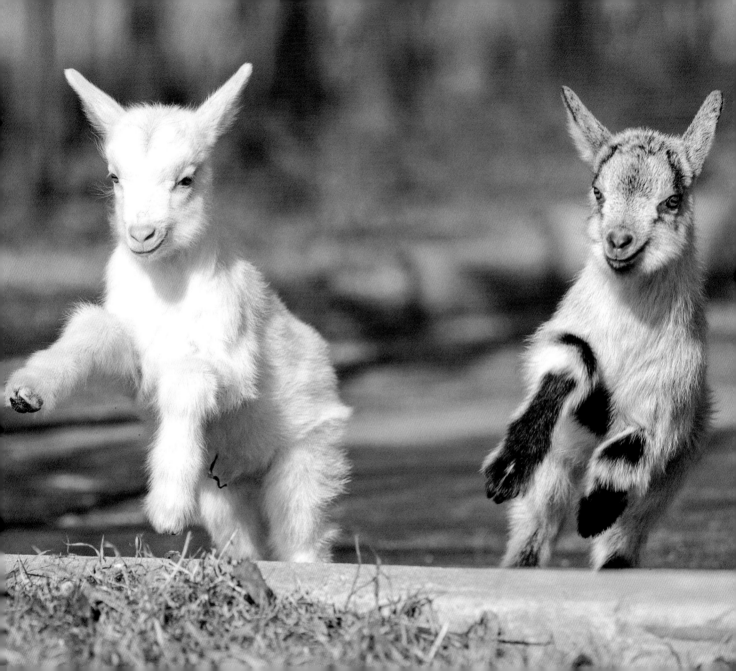

LIVE LIKE SOMEONE LEFT THE BARN DOOR OPEN.

TURN ALL OF YOUR FROWNS UPSIDE DOWN.

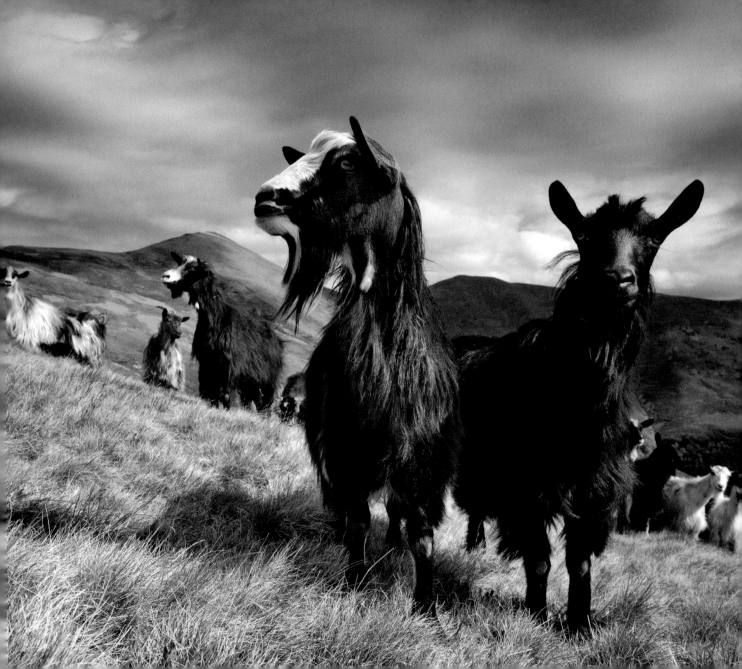

HOP THE FENCE EVERY ONCE IN A WHILE.

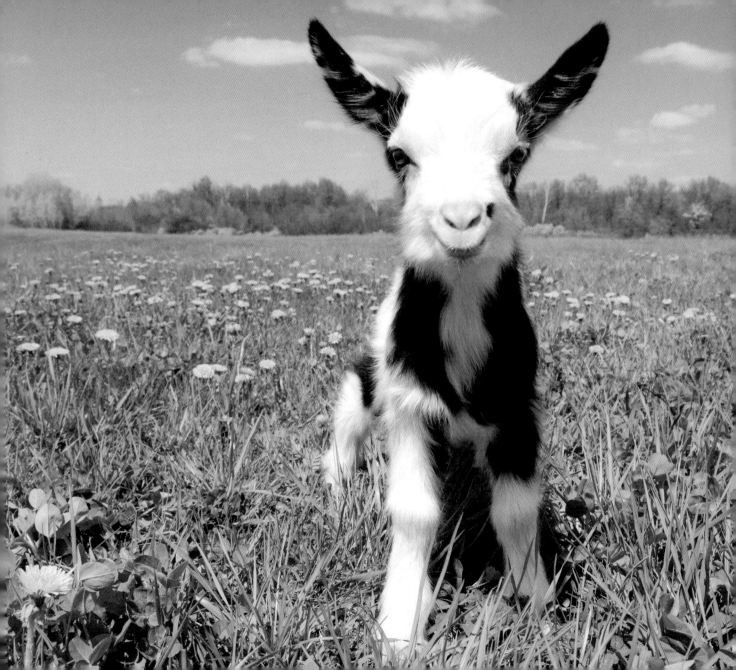

HAPPINESS BLOOMS FROM WITHIN.

THINK BEAUTIFUL THOUGHTS.

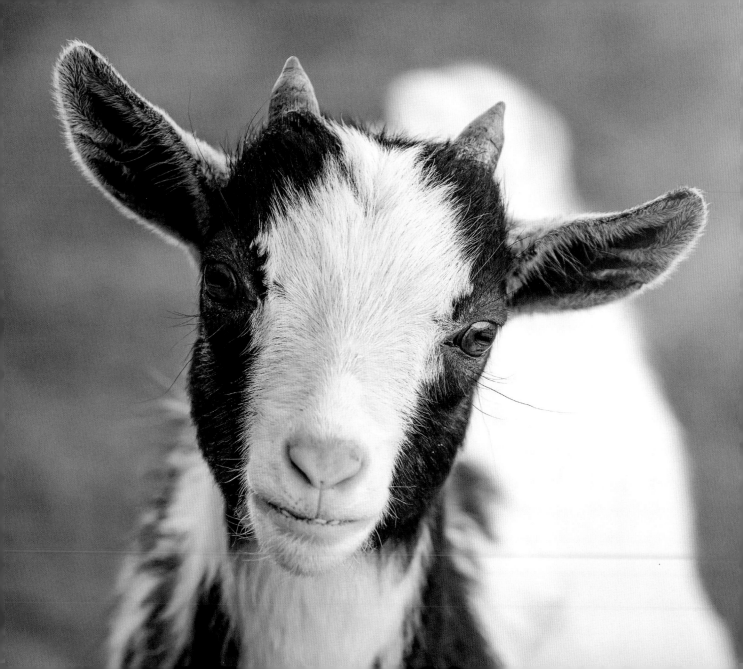

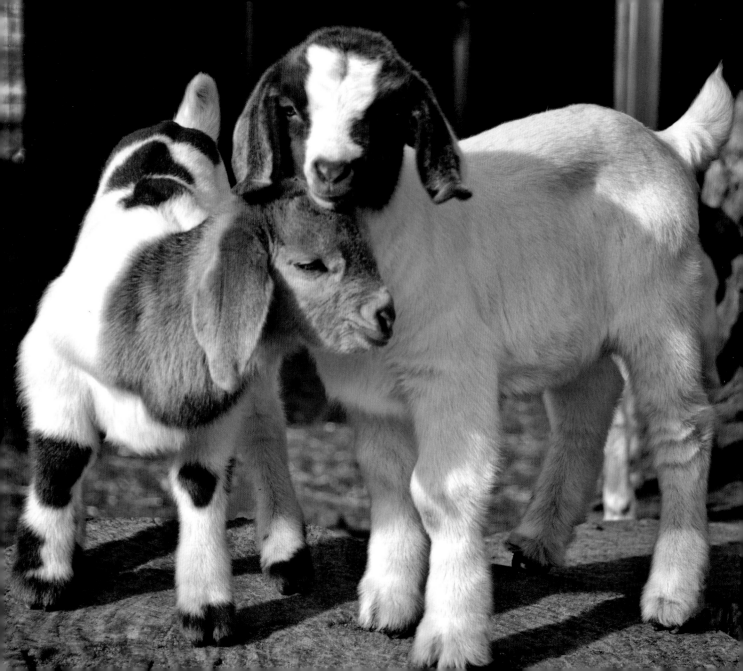

SIBLINGS ARE OUR FIRST LESSON IN FRIENDSHIP.

IT'S ALL FUN
AND GAMES

UNTIL
SOMEONE
LOSES
A HORN.

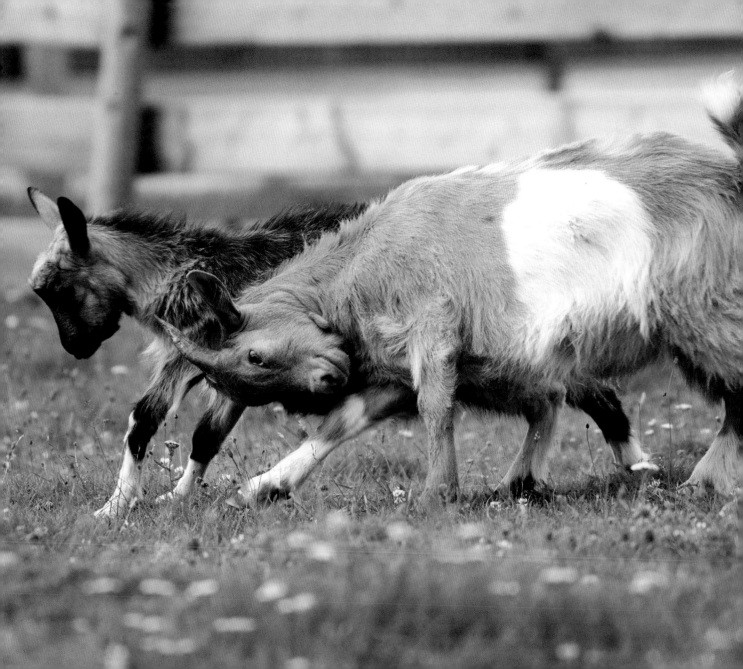

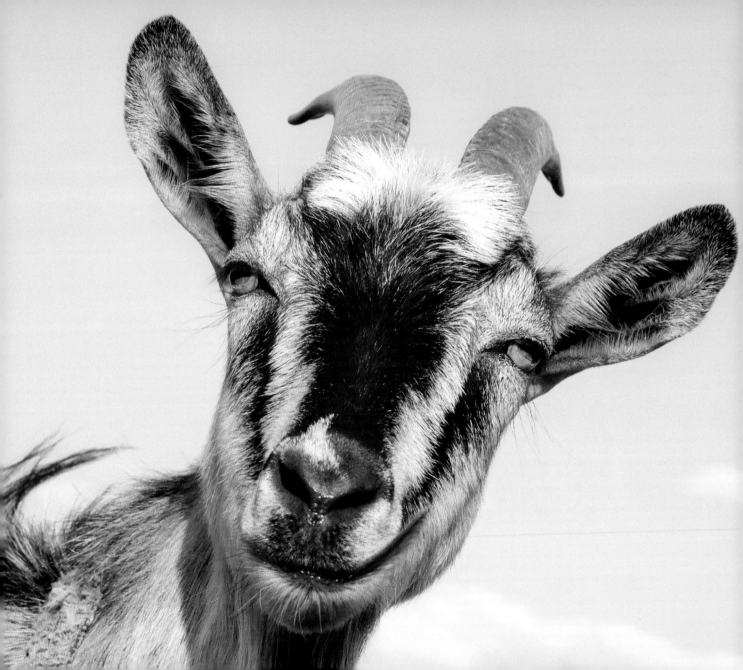

YOU'VE GOT THIS.

YOU CAN'T LIVE
A FULL LIFE

ON AN EMPTY
STOMACH.

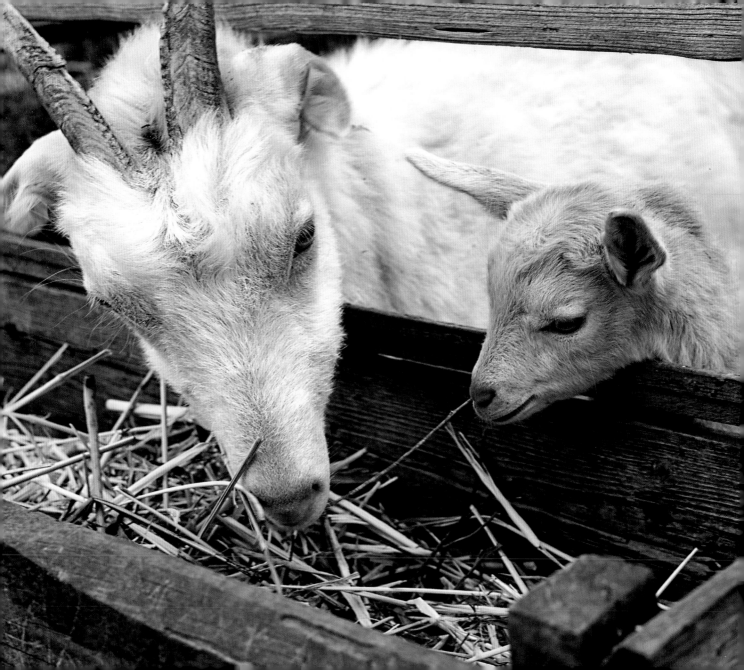

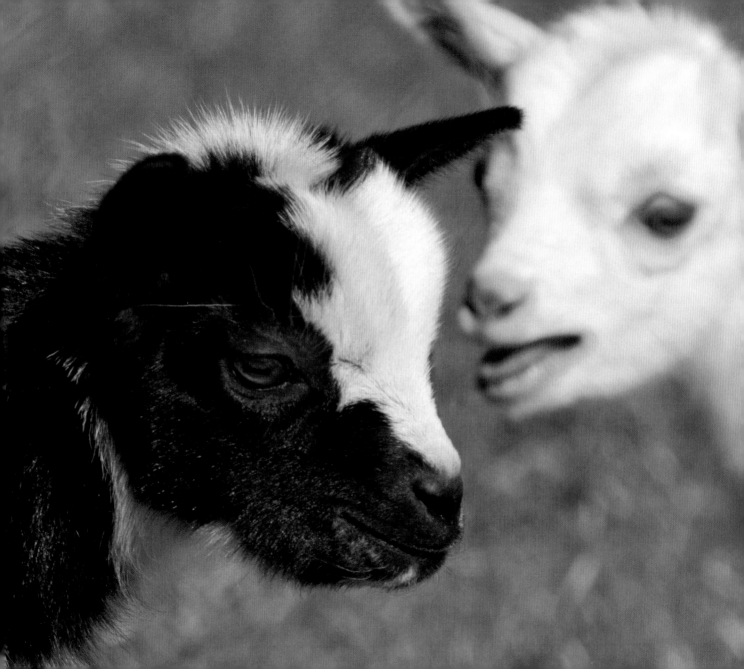

THE BEST FRIENDS KNOW HOW TO LISTEN.

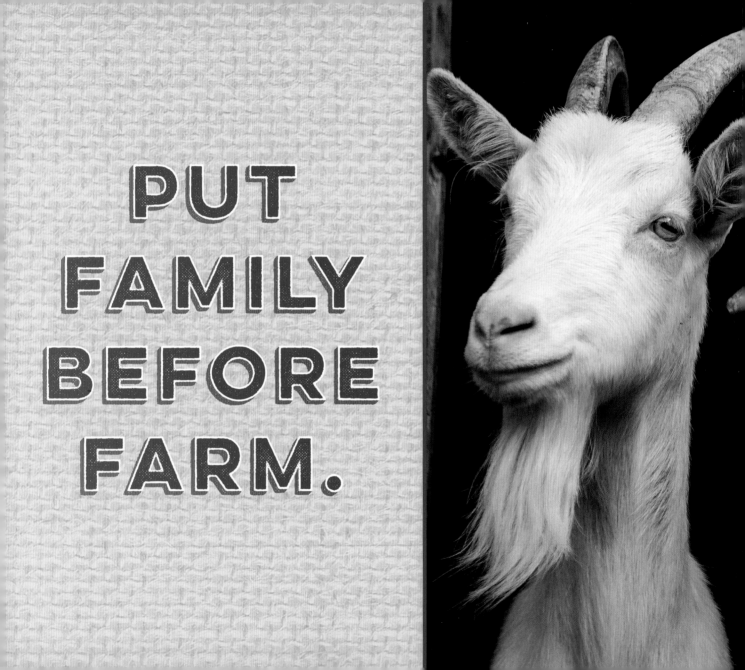

PUT FAMILY BEFORE FARM.

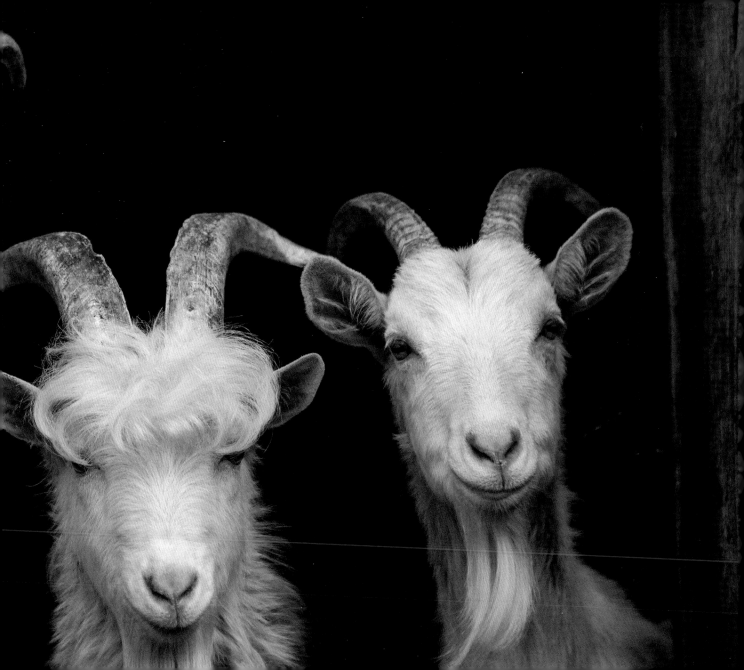

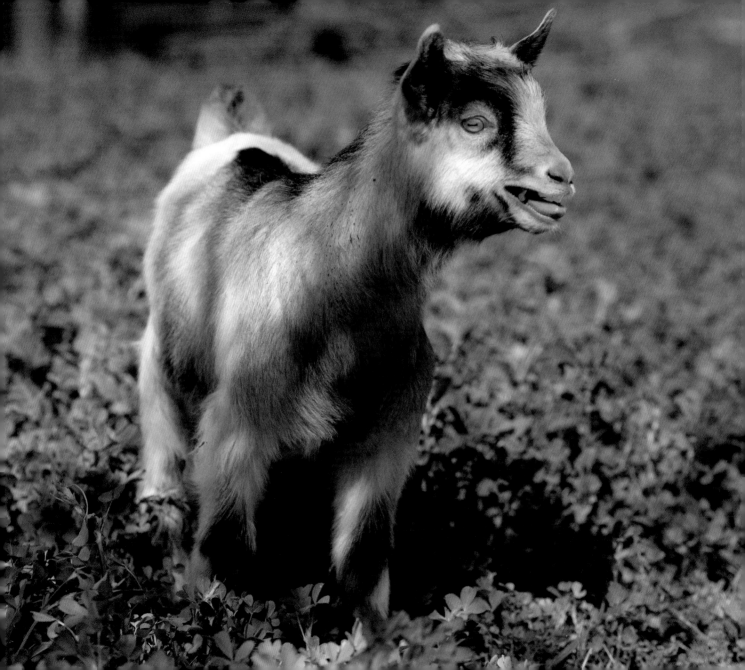

MAKE SOME NOISE.

BELIEVE IN SOMETHING
WITH ALL YOUR HEART.